BYGONE CLYDE VALLEY — THE ORCHARD
by KENNETH LIDDELL

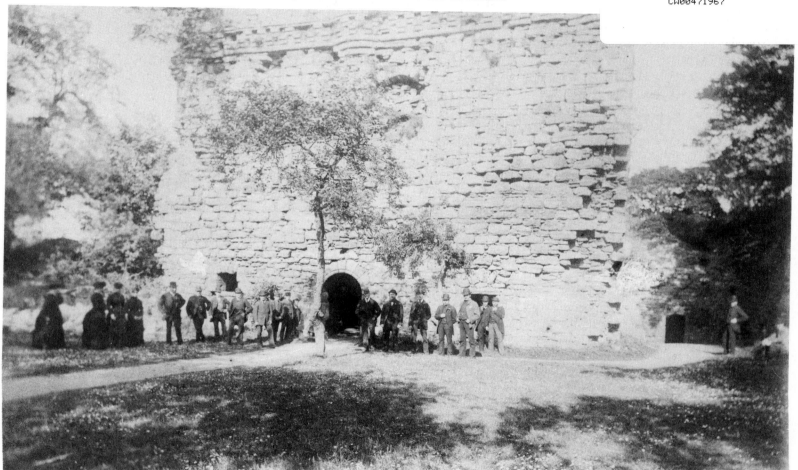

Craignethan (Tillietudlem) Castle on a glorious summers day sometime in the 1890s.

ISBN 1-872074-06-5

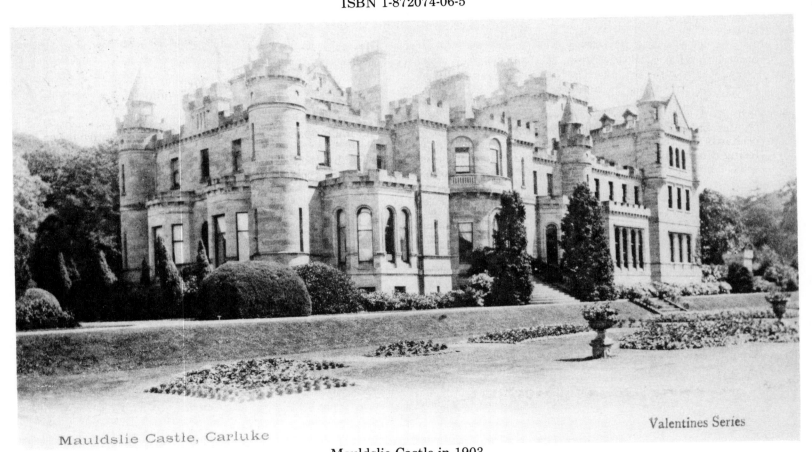

Mauldslie Castle, Carluke

Valentines Series

Mauldslie Castle in 1903.

INTRODUCTION

The fruit-growing area of the Clyde Valley used to reach as far downstream as Bothwell and Blantyre, but due to industrialisation and population spread has now "moved" upstream. Many Lanarkshire and Glasgow people converge on this wedge of greenery which starts between Hamilton and Motherwell and runs, mainly on the river course, nine and a half miles to the steep brae which leads up to Lanark. This area has been variously described as "Clydeside", the "Clyde Valley", even just "The Valley". To add to the confusion, all these terms are also employed to describe the entire valley stretching as far as Greenock! Finally, the A72 road is also known locally as the "Valley Road".

Whatever, the suffix "The Orchard Country" I hope will convey the nature of the charm of this area. The valley's shelter and highly fertile alluvial soil have made fruit-growing its main business for centuries. Today there are fewer orchards and the tomato-growers have experienced difficult periods, but the development of garden centres, some offering direct participation in berry-picking has perhaps saved a few businesses. For those of you unfamiliar with the area, I hope this book will spur you on to explore one of the West of Scotland's best kept secrets.

I am grateful to the staff of Lanark and Hamilton libraries, and to archivists Helen Pugh and Fiona Watson of the Red Cross and Grampian Health Board respectively, for assistance in getting to the root of much of the information in this book. Much was also gleaned in conversation with Sir Andrew Gilchrist, Mrs. Sadie Ferguson, Mr. Bill Muir, Mr. Tom Lumsden, Mr. Tex McGuinness and the many others who contributed titbits of information.

I am particularly indebted to Mrs. Janet Murray, whose crystal-clear recollections illuminated many "grey" areas. Mrs. Murray appears in one of the early picture postcards of Dalserf Village illustrated in this book.

Finally, I wish to record my thanks to Richard Stenlake for the opportunity to produce this volume, and to my family for their forbearance during the last few months.

Kenneth Liddell, June 1991

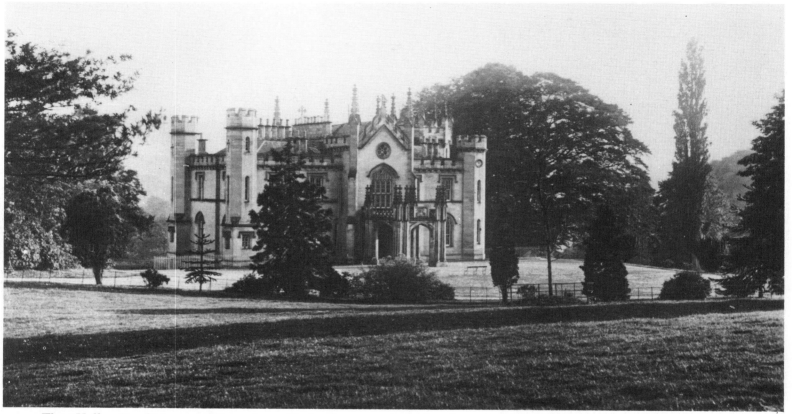

The "Valley Road" is generally reckoned to begin approximately where the A72 Hamilton to Lanark section is joined by the Lanark/Larkhall slip road from the M74. The A72 plunges and twists towards the Clyde, opening onto a pastoral vista as the high flats of industrial Motherwell are left behind. Here the road follows closely and close by the river and, looking to the north bank, the once fine Gothic mansion of Cambusnethan appears, now a gaunt ruin.

Cambusnethan House replaced a 17th century manor house destroyed by fire. James Gillespie Graham was commissioned by Robert Lockhart of Castlehill to design the house, which was erected between 1810 and 1819. Since it was last used in 1984 as a medieval banquet "priory", there has been uncertainty about its future. Meantime, vandalism and the effects of lack of maintenance place the house at considerable risk.

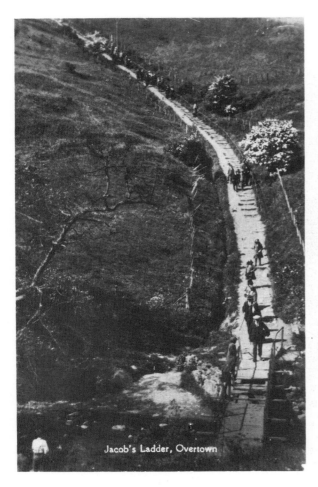

Jacob's Ladder, Overtown

This remarkable 365 step descent into Garrion Gill was a popular subject for the picture postcard photographer. Jacob's Ladder attracted Glasgow tourists by rail to Overtown which is situated on the Garrion Burn above and to the north of the Clyde.

The path wound down through orchards and strawberry fields. Summer picnics during the Glasgow Fair and egg-rolling at Easter were particularly popular. Some holidaymakers even camped by the burn.

Overtown's coal miners not only worked the local pits but also those around Law, while Law miners equally worked the Overtown pits. The direct route beteen the two was by Jacob's Ladder. This route remains a right of way today. The steps were completely upgraded within the last few years.

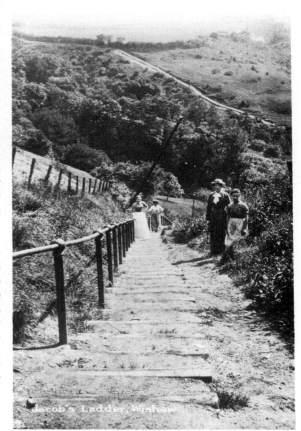

Jacob's Ladder, Wishaw

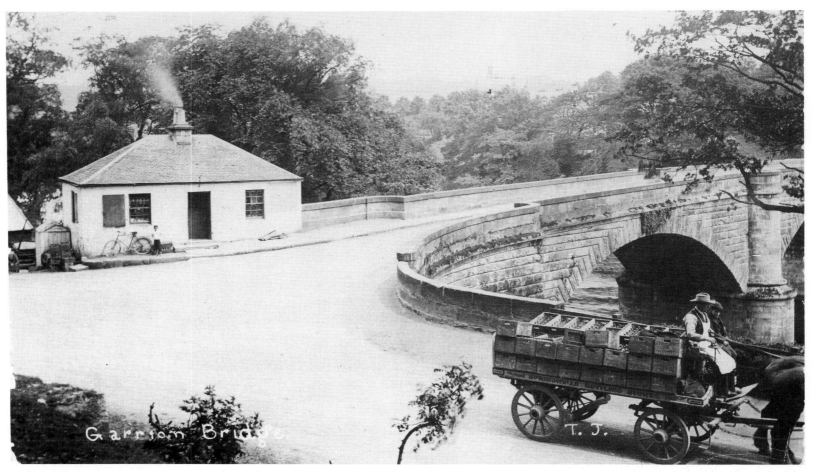

Garrion Bridge

T. J.

Garrion Bridge marks the "B" listed meeting point of three District Council boundaries and two "A" class roads. Its elevation to such importance dates from 1817 when the three span rubble structure, based on a Telford design, first straddled the Clyde. This was, at the time, the sole dry crossing point between Lanark and Bothwell, a point alluded to by the fading inscription on a plaque on the Hamilton side. The plaque can be seen on the wall of the shop (formerly the toll house) shown in the photo.

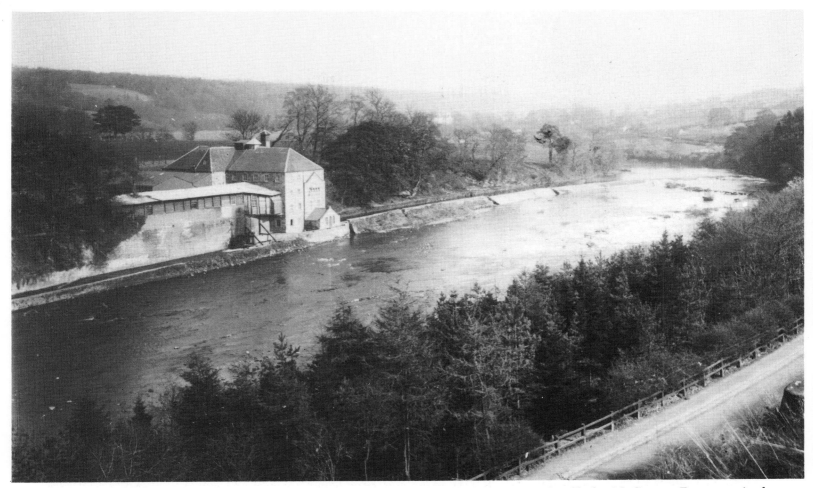

Garrion Mill processed local grain using water power from the nearby weir on the Clyde. McGregor Bros acquired Garrion Mill from John Brownlie after World War One, enlarging it and emblazoning on the side a legend familiar to many Clydeside visitors: "For Man Beast Fowl — Better Canna Be". The mill was converted to a private house in the 1980s.

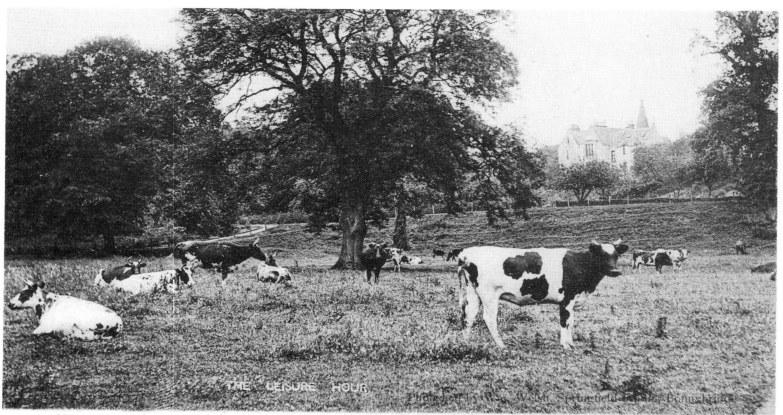

The Leisure Hour. Garrion Tower, on the Clyde

The ownership of the lands of Garion (Garrion) was, in ancient times, in the hands of the Barony of Glasgow as the church of Cadihou (Cadzow). Here was the Chapelry of St. Mary Machan, an outpost of that church.

The origins of Garrion Tower are obscure. The present L-shaped tower is thought to be of late 16th century construction, possibly built by Sir James Hamilton of Finnart, son of the first Earl of Arran. An association with the Bishops of Glasgow has also been suggested. The tower may have been used by them as a summer residence. In the 18th century, the tower is found referred to as the "Peilhouse".

8

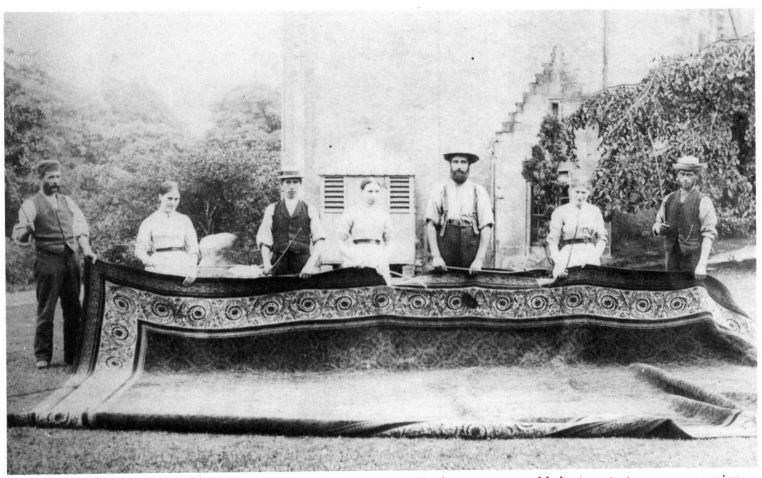

The Tower House was dilapidated when restored in the 1830s. To the tower was added a twenty-two room mansion house (1840). At the time of the above photograph (1880s), the Scott family was in residence. One of the dubious pleasures for the domestic staff in the "big house" was carpet-beating. Note the relatively primitive beaters in vogue at this time. The lady on the left is Mrs. Murray's mother, Mrs Mary Ritchie. On the right is Mary McFadyen who later married Clark, the blacksmith at Dalserf.

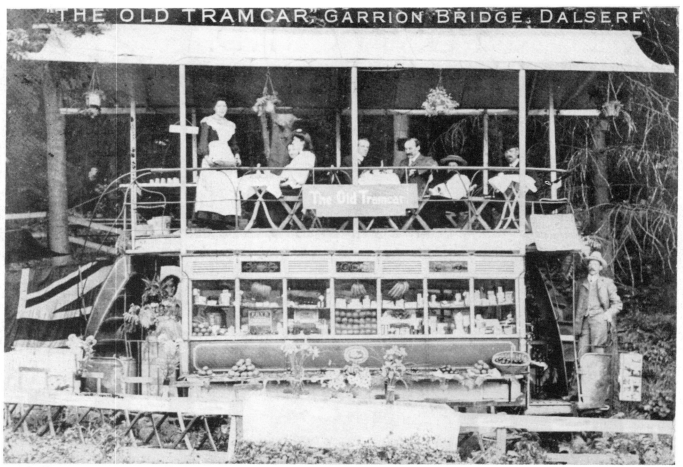

A Larkhall entrepreneur installed this old horse-tram near Garrion Bridge on the Dalserf side for the express purpose of providing sustenance to passing walkers. This area was a popular meeting place for miners and other trade unionists in the early years of the century. Rallies were held regularly, addressed by such prominent political figures as Robert Smillie and James Maxton. The hundreds attracted to these events doubtless provided considerable business for the Old Tramcar.

10

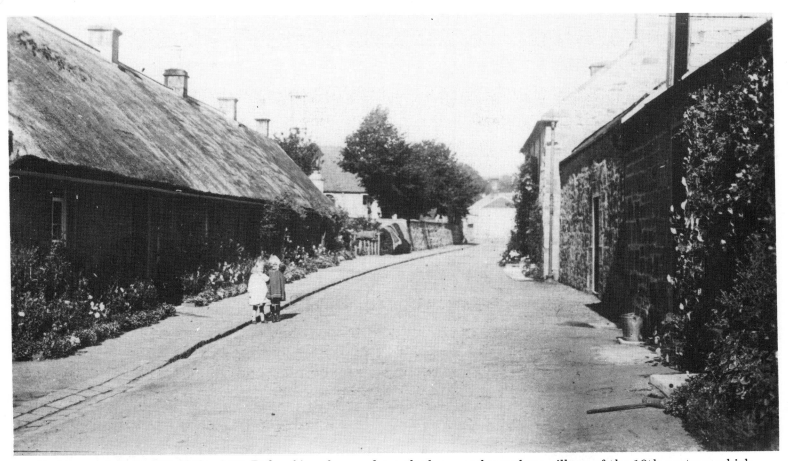

Today a mere hamlet off the A72, Dalserf is a far cry from the busy and populous village of the 18th century which stretched uphill beyond where the A72 runs and was a strategically important halt and river ford on the main coaching routes. The village has lent its name to the parish beyond since the 17th century. "Dal" is Celtic for "meadow" and it has been suggested that St. Serf (who was St. Mungo's teacher at Culross) established a chapel here. However, as the original name of the settlement was Meeheyn, it seems more likely that the village was simply named in his honour.

The cottages above were built in the 1650s and remained thatched until the late 1950s.

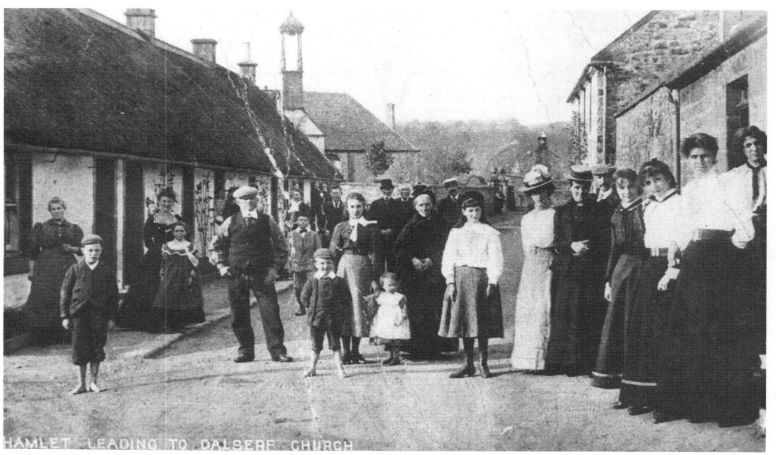

HAMLET LEADING TO DALSERF CHURCH

Most of the Dalserf villagers turned out to pose for this postcard in 1901. Mrs. Janet Murray's family (Ritchie) are well represented here. From left to right are:

Mrs Muir (Factor's "man"'s wife), John Ritchie, Miss Copeland and her niece, Jimmy Muir (Factor's "man"), unknown, unknown, John Scott, David Ritchie (front), unknown, Agnes Ritchie, Janet Ritchie (Mrs. Murray, child at front), John Ritchie (Beadle), unknown, Janet Ritchie (Beadle's wife), unknown, Ena Copeland, Margaret Ritchie, Mary Ritchie (mother), Laurence Ritchie (father), two Misses Copeland, Teen Fleming and Mary Scott.

12

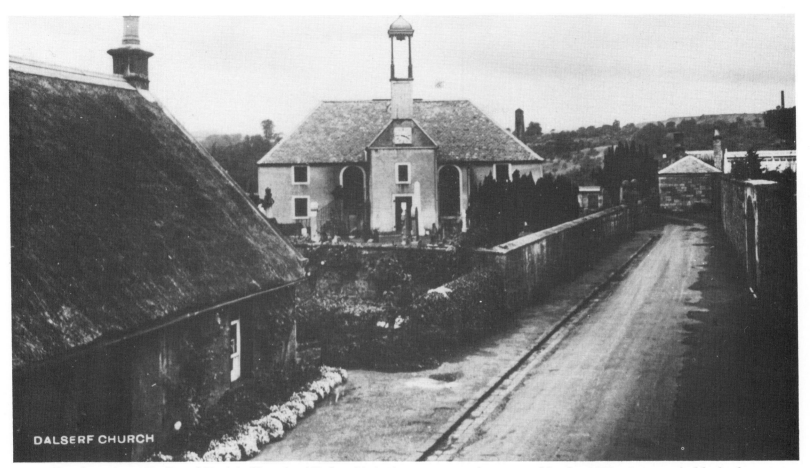

DALSERF CHURCH

The charming "B" listed Parish Church of Dalserf (1655), most recently restored in the 1970s, is remarkable for having outlasted many similar post-Reformation structures. The distinctive oblong shape was later augmented by lateral extension galleries and a belfry.

The paternal influence of the local gentry survives in their respective pews, which have long outlived the mansion houses of Mauldslie and Dalserf, while convenanting associations are celebrated by the memorial to the Reverend John McMillan.

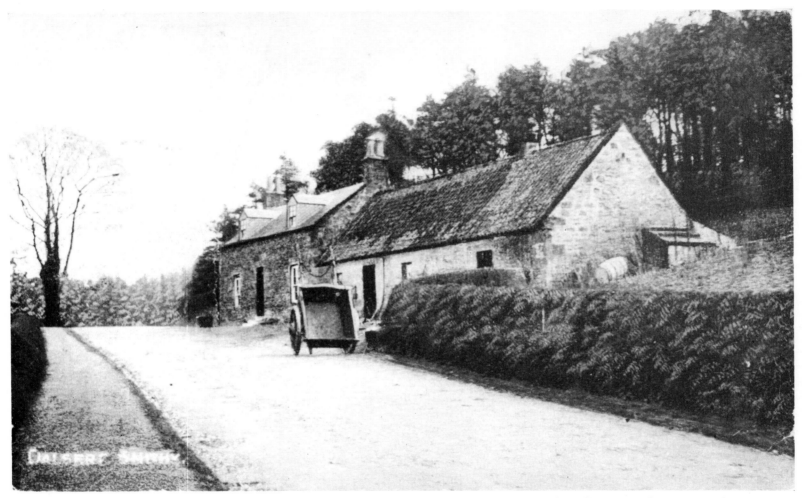

The Smithy House, Whindyke, still stands on the A72 just before the left turn to the village. On the right of the picture is the forge (now demolished) with the byre on the extreme right.

The Clark family occupied the smithy for many years. The upturned cart suggests an equine client is receiving Mr. Clark's attention!

14

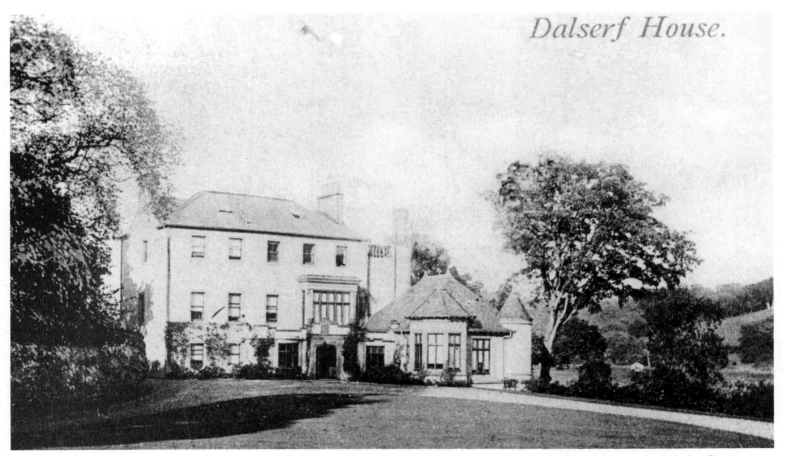

Dalserf House.

This handsome mansion (circa 1700) was, like Hamilton Palace, the victim of underground mineworkings, leading to its demolition in the 1950s.

The house and estate provided employment in Dalserf village and were the property of the Hamiltons of Dalserf who also owned the nearby estate of Millburn. Ownership latterly passed through the female line via the Campbell-Hamiltons to the Henderson-Hamiltons who still administer the estate. The Lodge House, on the A72, and the Coach House (originally the stables) remain.

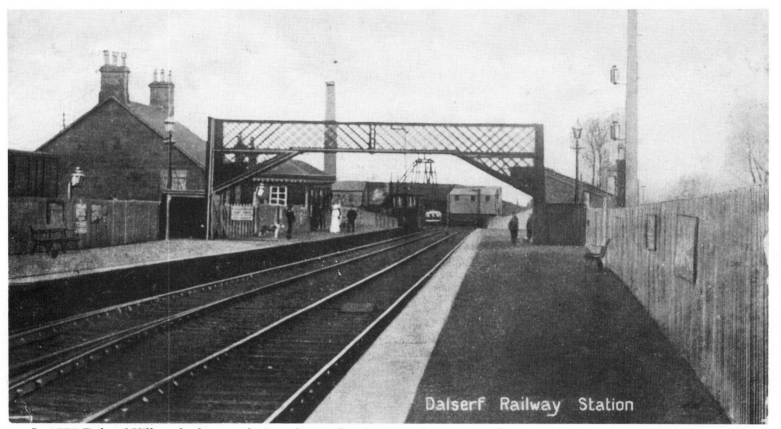

Dalserf Railway Station

In 1775 Dalserf Village had a population of 1100, but by 1841 there were only 112 residents while the parish around was experiencing considerable growth through weaving and coal-mining. It seems likely that this drastic shrinkage in the village population was due to the most immediate mines becoming exhausted or unworkable.

Mining was not the only industry though. From early times fruit cultivation had been important. The premier fruit in 1841 was the plum, but a wide range of apple and pear varieties, occasionally gooseberries also, were propagated. Dalserf Station, which was actually near to Shawsburn and a considerable uphill walk from Dalserf, was the main departure point for fruit being exported from the area. It was opened in 1856 on the Caledonian Railway's Motherwell-Lesmahagow branch line and was originally known as "Ayr Road".

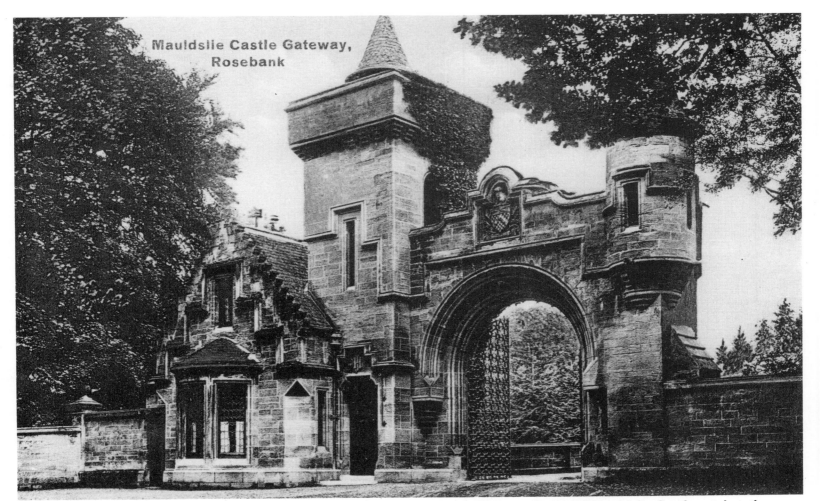

In the dark winding stretch of road from Dalserf the ornate former West gatehouse of Mauldslie Castle catches the eye. The Gothic lodge has been tastefully enlarged and restored in recent years. Through the arch, a fine freestone bridge spans the River Clyde. Both structures date from 1861 and are "B" listed.

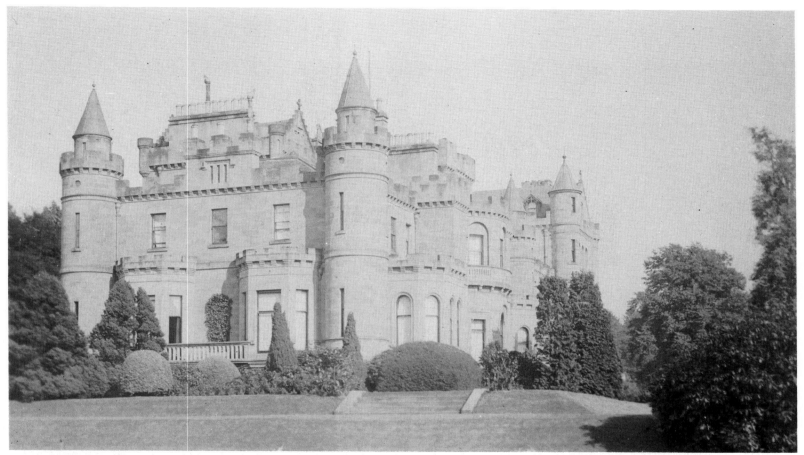

The name "Mauldslie" was originally associated with much of the area now constituting Carluke Parish, forming part of a royal forest. The Barony of Mauldslie dates from the 14th century, the first Parish Church of Carluke, Forest Kirk, being established here.

Mauldslie Castle was built to an Adam design by the 5th Earl of Hyndford in 1792-3 with later Baronial additions. James Hozier of Newlands purchased the estate in 1850. His son, William, was elevated to the peerage in 1898 as Lord Newlands, being succeeded in 1906 by his son James.

18

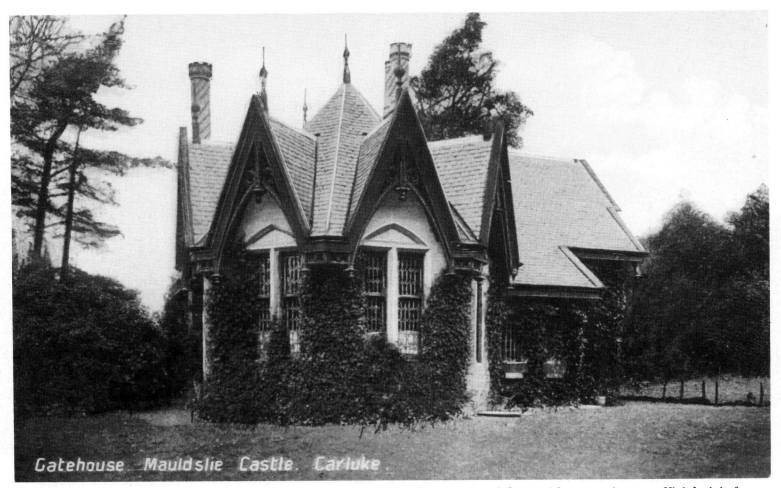

Gatehouse Mauldslie Castle. Carluke.

In July 1914 the Newlands had the honour of receiving King George V and Queen Mary, paying an official visit for lunch, at Mauldslie. The royal party made their way to Mauldslie via the East Lodge along a route "ablaze with bunting". The lodge was suitably decorated for the occasion with a banner of St. George.

The Gothic/Victorian eclectic East Lodge still stands on the Carluke-Brownlee road.

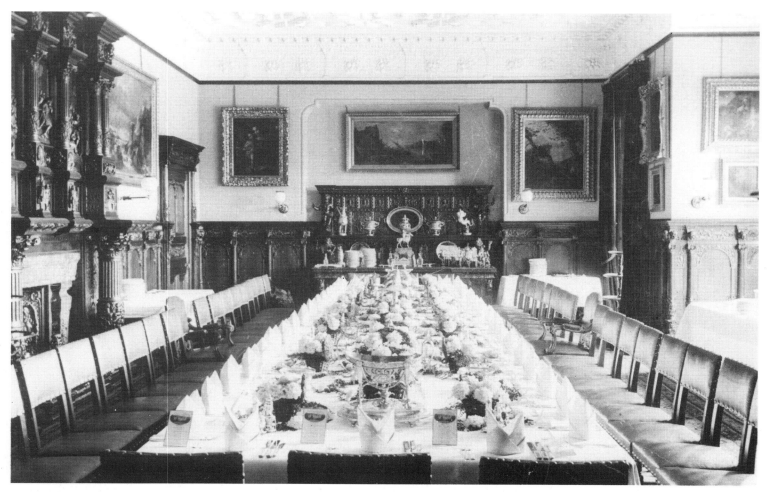

Luncheon guests at Mauldslie included Princess Mary, the Duke and Duchess of Montrose and all (it seems) of the Lanarkshire nobility. From this high point in Mauldslie's history, it seems difficult to believe that the castle was demolished only 21 years later following mounting problems with the upkeep of the estate by the heritor, the nephew of the 2nd Lord Newlands.

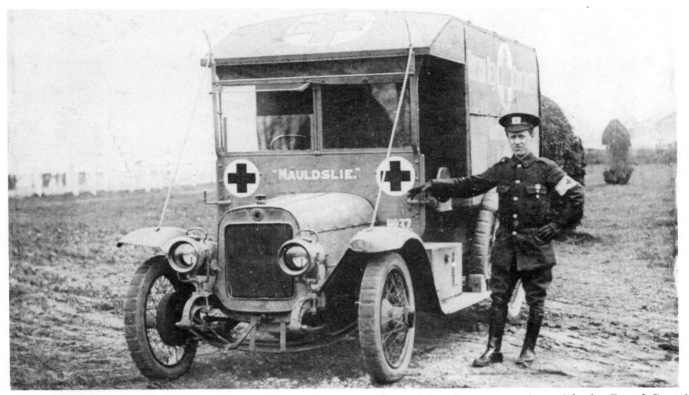

On the 12th October 1914, the Scottish Red Cross Transport Committee, in co-operation with the Royal Scottish Automobile Club, issued a national appeal for the provision of motor ambulance transport, urgently needed at the front and at home.

Lord Newlands was present at the meeting in Glasgow, announcing his intention to "present a fully equipped motor ambulance to be sent to the front, and, if they were permitted to give it a name, they would call it 'Mauldslie'". The Newlands were ardent supporters of the war effort; in addition to making available the Lady Hozier Convalescent Home in Lanark for returning wounded, they raised £3,900 in 1915 by auctioning a Stradivarius violin!

Mauldslie No.37 was one of 134 donated Scottish Red Cross ambulances employed during World War One and was possibly a motor car conversion. The white rails in the background may indicate two possible locations where this ambulance was deployed. It may be Lanark Racecourse — Lanark was one of the receiving stations for ambulance trains. Alternatively, if No.37 did serve at the front, then the racecourse could be Rouen, France, on which the Scottish Branch of the Red Cross set up and maintained a 270 bed "Scottish" Hospital.

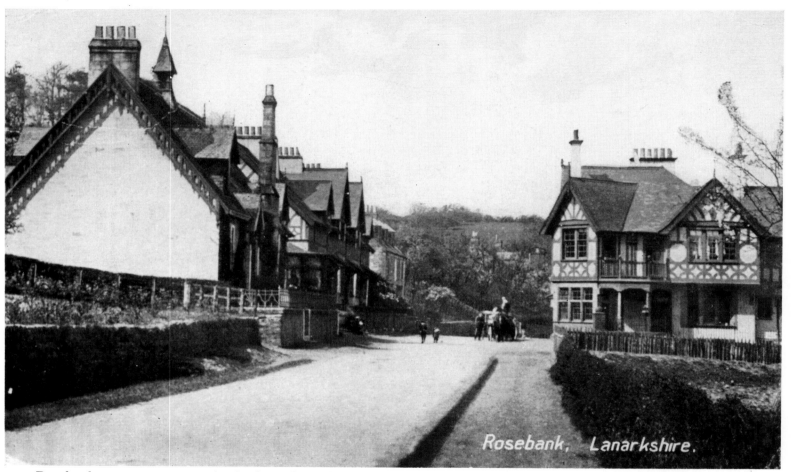

Rosebank, Lanarkshire.

Rosebank grew as a community in the early 19th century at the expense of the nearby contracting village of Dalserf, but, even then, was constrained from further growth by the lack of available feuing land. Thus the population has lingered between 100 and 200 since 1841 to the present, the Mauldslie Estate providing a valuable source of employment for the villagers prior to 1933. The current population is mainly commuting, partly agricultural. Orchards and nurseries still fringe the village, arguably the prettiest in the valley.

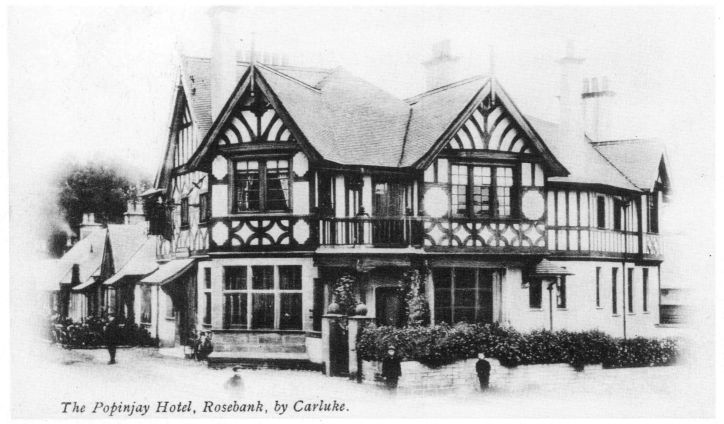

The Popinjay Hotel, Rosebank, by Carluke.

The 1st Lord Newlands refurbished Rosebank as a "model" estate village at the end of the last century. Included in this project was the creation of several Tudor style buildings of which the Popinjay Inn is the most celebrated, designed by Alexander Cullen of Hamilton and built in 1900 on the site of the former one-storey and probably thatched Rosebank Inn.

The Popinjay legend is fully described in Sir Walter Scott's "Old Mortality" to which the reader is referred. Briefly, the popinjay was a multicoloured parrot-like effigy used in competitive target practice (archery/firearms), the victor being required to fund the evening's entertainment in the hostelry. The obvious tourism potential of reviving this custom has been realised in recent years by its staging in the Popinjay grounds as a clay pigeon shoot.

23

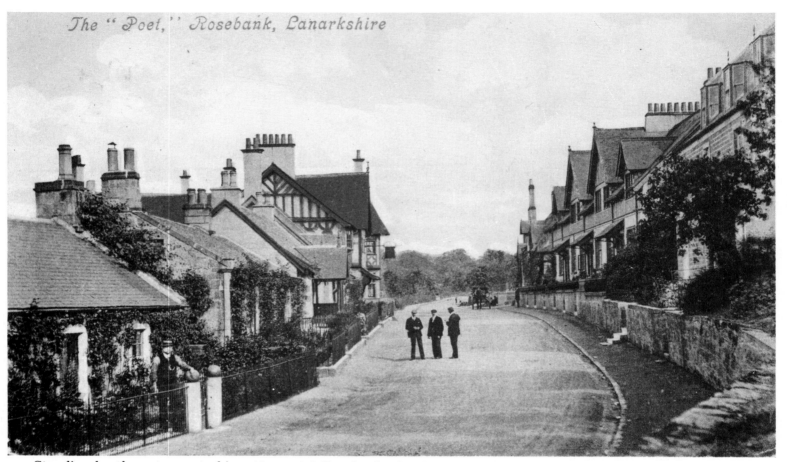

Standing by the entrance to his cottage at 3 Rosebank, the "Poet" is Alexander "Sandy" Thomson. Information about him is scant, and his works of poetry are not recognised in national or local reference sources. He may therefore have been a doggerel poet of the late 19th century.

He was a gardener/labourer, probably employed in Mauldslie Estate, and is remembered as a Sunday School teacher in Rosebank Hall. Born in Motherwell in 1846, the son of a forester, he died around 1915.

The prominent gateposts, on which the poet is leaning, can still be seen though his cottage now forms part of a larger house.

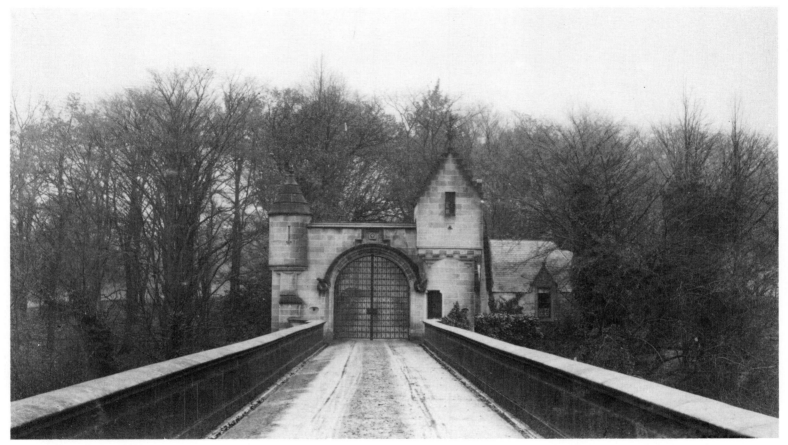

This bridge across the Clyde, its gate, and its watchtowers ("B" listed), were the entrance to the Milton Lockhart Estate. Architect Burn's designs borrowed heavily from ancient Scottish buildings. The bridge's ribbed style is based on the old Bothwell Bridge. It is located by the A72, just south of Rosebank and well worth close inspection. The fine gates remain, these days firmly padlocked, somewhat inhospitably. The craftsmanship of the stone ropework on the watchtowers is excellent, and one can only hope that this marvellous little edifice will fare better than the house to which it was entrance. The gatehouse was actually used as a residence in comparatively recent times by Jimmy Crawford and his family.

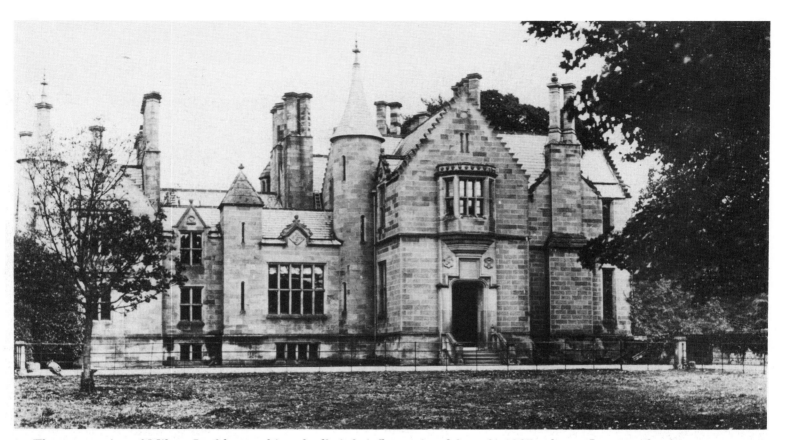

The sorry ruins of Milton Lockhart achieved, albeit briefly, national fame in 1987, when a Japanese businessman announced his intention (later accomplished) to transport the house stone by numbered stone to Hokkaido where it was to be the centrepiece of a toy museum.

If Milton Lockhart had a fairy tale ending, its origins in 1829 were equally so. William Lockhart M.P. commissioned William Burn, the Edinburgh architect, to build the Baronial mansion on a green knoll hemmed in by a curve of the Clyde, the course of which had been diverted. The site was reputedly the choice of Sir Walter Scott, whose son-in-law was Lockhart's half-brother; indeed Scott made another visit to inspect progress and pronounced that "it may be the prettiest place in Scotland".

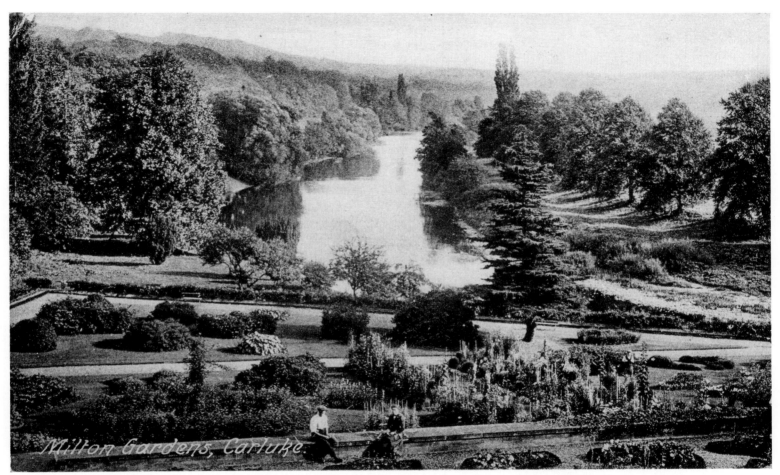

Milton Gardens, Carluke

The Lockharts retained Milton Lockhart until World War Two when the condition of the then empty house was deteriorating. By 1952, when the estate was sold, the house had become uninhabitable. Renovation costs became prohibitive to the new owners in the years following and the house steadily decayed.

Milton Lockhart's gardens were frequently opened to the general public under the Scotland's Gardens Scheme. During the 1950s, beginning in Coronation Year, an annual fête in the gardens became a popular feature.

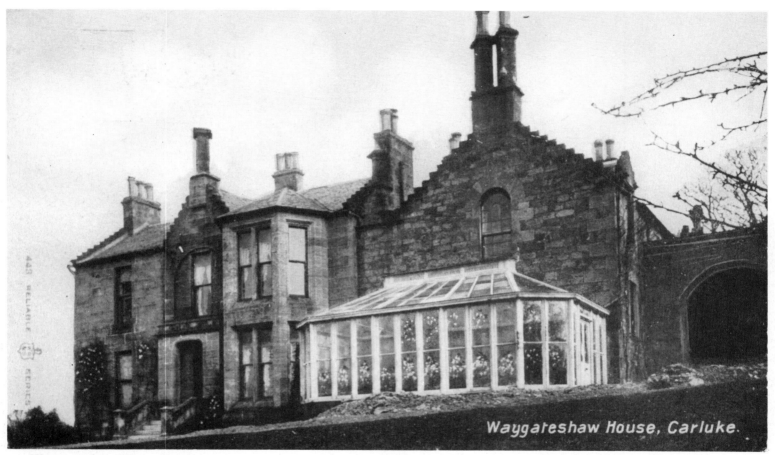

Waygateshaw House, Carluke.

Waygateshaw House lies in a 27 acre estate on the steep north-east bank of the Clyde in the Parish of Carluke, directly opposite Sandyholm. The 16th century tower at the north-west end was supplemented by a 17th century wing, with later extension to form a square. The house was a Lockhart seat, but later was owned by the Steels for many years. Wedged in between these ancient local families was a brief interlude when the unfortunate Major Weir of Kirkton held sway. Weir was widely regarded as a devil worshipper and though the description of his "misdemeanours" seems rather vague today, they were sufficient to have him (and his sister) convicted of witchcraft in 1650. Weir had the doubtful honour of being one of the last Scots to be burned at the stake for this crime.

28

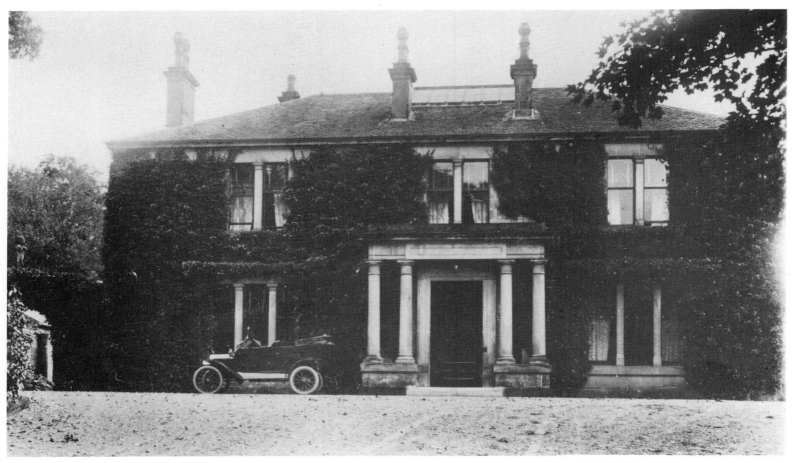

One mile along "Cozie Glen", the winding narrow glade on the north-east side of the river, lies Orchard House, erected in the early part of the 19th century with later Victorian additions. The Orchard Estate had been the birthplace in 1790 of Robert Forrest, the sculptor (most notably of the Wallace statue at Lanark Cross). The Scott brothers migrated to the area in 1869 from Uddingston, initiating at Orchard the first mass cultivation of strawberries in the valley. They later opened a processing factory in Carluke for preserving surplus fruit.

Orchard House became a 27 bed nursing home in 1988. The house and octagonal pavilion are listed buildings.

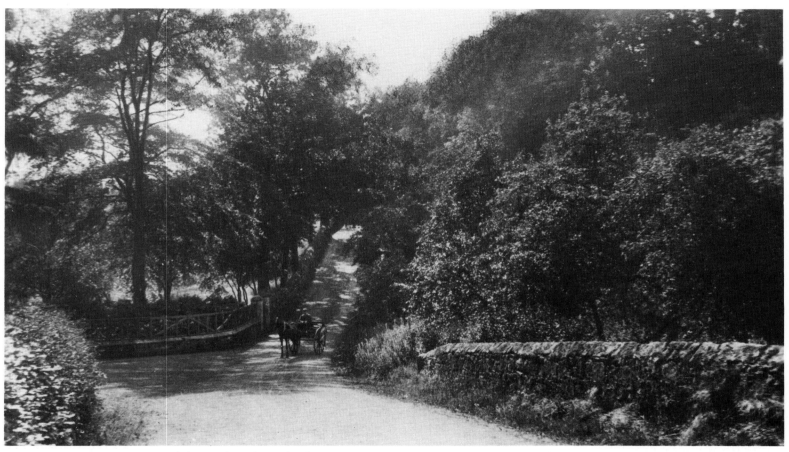

It is difficult today to believe that Crossford at one time provided major local employment in the mining industry. However, just along from Orchard Estate entrance, on Cozie Glen road ("Back Path" road) was sited Orchard Pit, which closed in 1887 while New Orchard Pit was also located nearby in the Orchard Estate (closed in the 1890s).

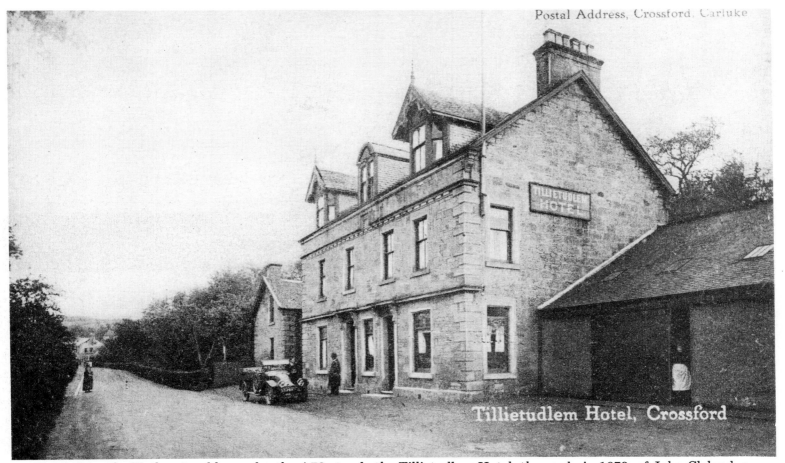

Tillietudlem Hotel, Crossford

Near where the Nethan tumbles under the A72 stands the Tillietudlem Hotel, the work, in 1879, of John Cleland, a local builder and joiner. The Cleland family owned the hotel until 1947, John Cleland himself becoming the licensee in 1906.

The hotel was advantageously positioned to benefit from the proximity to the Victorian tourists' "hot spot" of Craignethan Castle, while it also accommodated competitors in the Tillietudlem Games, as well as catering to the needs of thirsty locals and fruit salesmen.

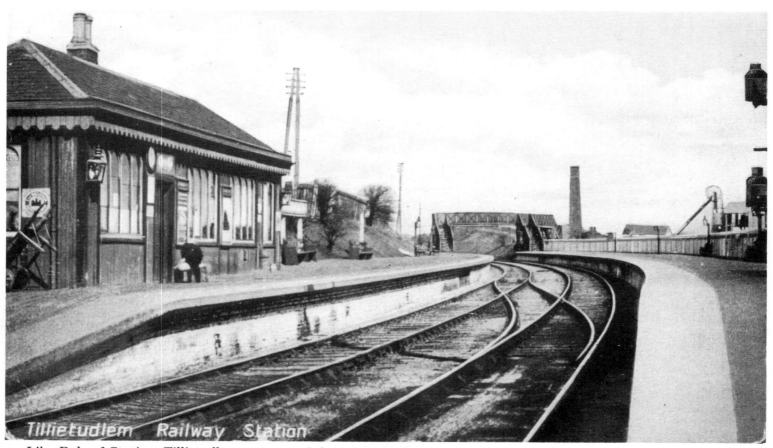

Tillietudlem Railway Station

Like Dalserf Station, Tillietudlem was one of the original halts (1856) on the Motherwell-Lesmahagow branch line (Caledonian Railway). The station served the nearby Craignethan Castle, romanticised by Sir Walter Scott in "Old Mortality" as "Tillietudlem Castle", the fictional name becoming inseparably linked with the area. The hamlet community of Tillietudlem evolved around the halt. Pits in the area, including Fence and Old Fence, provided employment in the late 19th century. From Tillietudlem Station mineral trains transported coal both from the local pits, from Annabella Pit at Crossford, and from those beyond in the Coalburn and Lesmahagow fields. Passenger trains provided access to work in these areas for the Crossford miners. The last passenger train left Tillietudlem on 29th September 1951.

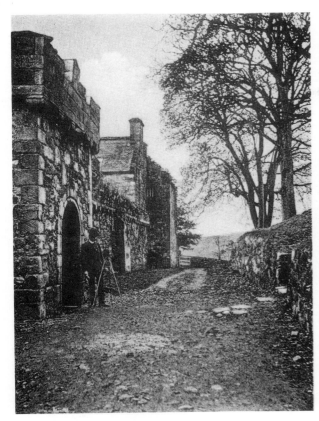

Craignethan Castle stands on a precipitious promontory overlooking the ravine of the Nethan about one mile south west of Crossford. On the fourth side, the castle is defended by a 30 feet ditch.

The original tower house, Draffan, is of uncertain age but the castle assumed its present aspect by the hand of Sir James Hamilton of Finnart (see also Garrion Tower), who added considerably to the landward side around 1530. Despite Craignethan's commanding appearance and position, its use was essentially residential, Mary, Queen of Scots being among its visitors. Support by the Hamiltons for her led to the castle being sacked in 1579, though Andrew Hay added a courtyard house after purchasing Craignethan in the 1660s.

Sir Walter Scott was impressed by Craignethan and introduced the alternative name "Tillietudlem" through his use of the castle as a model in "Old Mortality". Craignethan Castle is now in the care of Historic Scotland.

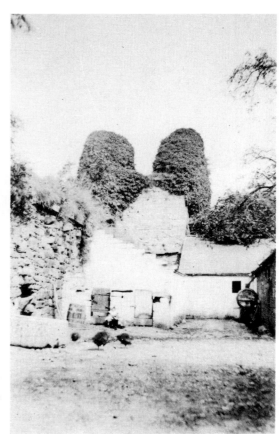

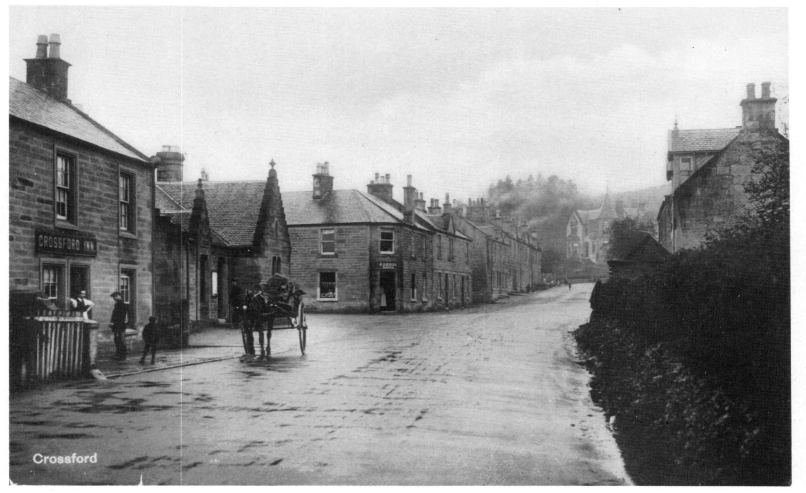

Crossford

The origin of Crossford's name is self-evident, the ford lying some 100 yards downstream from the bridge. Crossford is a considerable village, at the very centre of Clydeside, in a fertile holm where Nethan and Clyde merge.

The Crossford Inn is instantly recognisable, run at this time by Mrs. Thomson, whose husband George is possibly the doorway figure. The Post Office, managed by Miss Wilson, is on the right, while opposite is Leiper the baker, whose house, Drumassie, is visible at the end of the street.

34

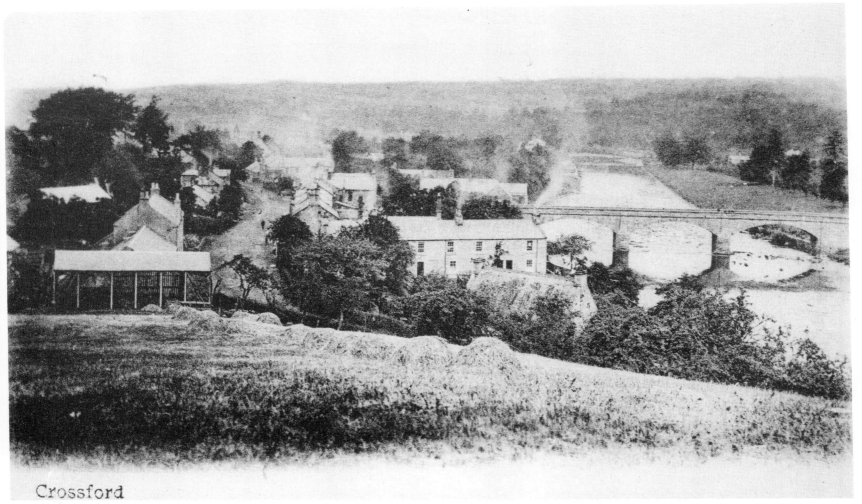

Crossford

An earlier (pre 1903) view of Crossford looking downstream, taken from above the site of the yet to be built Drumassie. This viewpoint was known as Stairheid Knowe, a favoured bonfire venue. The hill area in the foreground is shown in numerous period postcard views planted out either with grain crops or soft fruit.

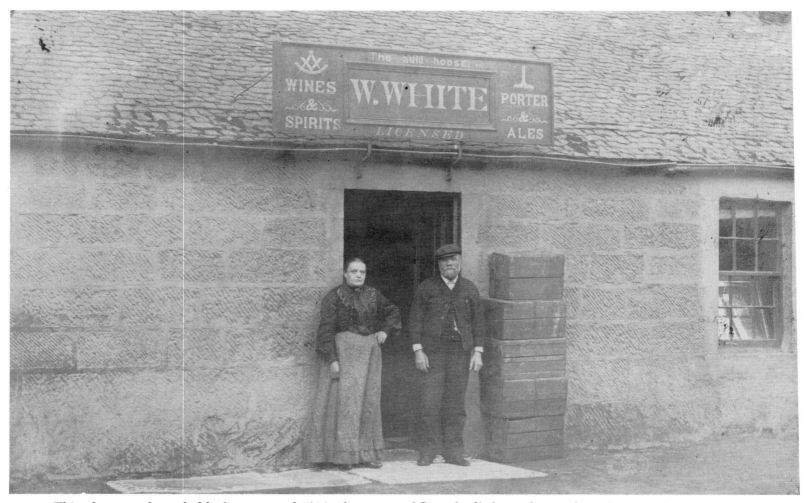

This photograph, probably from around 1910, shows one of Crossford's lesser known hostelries which was situated in Holm Road. The building is now a domestic residence. In the 1880s Crossford boasted 7 public houses!

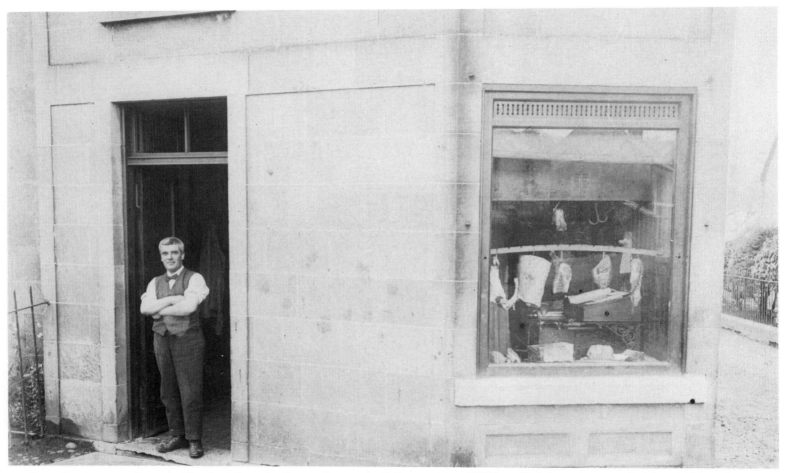

Crossford was well served by butchers in the early years of the century. William Fairley was one of at least three plying their trade. Fairley is seen posing in the doorway of his shop at the corner of Lanark Road and Holm Road.

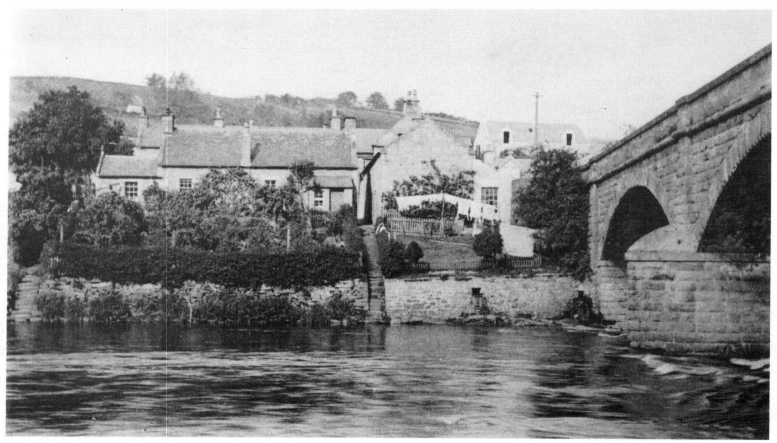

The bridge and toll house at Crossford were built in 1793. The bridge boasts three spans and is of dressed stone construction with segmental arches. Both structures are "B" listed. Access to the north-east bank of the Clyde at this point enabled the forging of commercial links with Braidwood village and, more importantly in the late 19th and early 20th centuries, Braidwood Station. From Crossford, fruit bound for market left by waggon for Braidwood, and thence by rail. "Cannel" coal (coal rich in gas and used to give illumination-candle) from the Auchenheath pits arrived by bogey at Brodiehill (above Underbank School), before being similarly transported via Braidwood Station. All this activity kept the toll keeper very much in business.

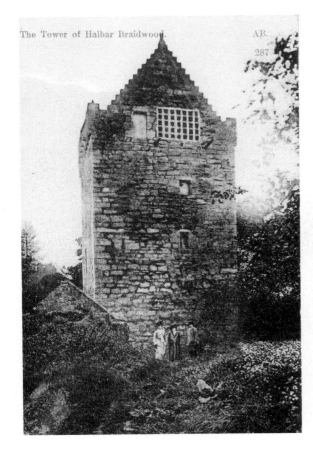

The Tower of Hallbar lies over Crossford Bridge, near the Fiddler Burn, a mile north of its confluence with the Clyde. Hallbar Tower is the finest remaining example of a Tower House in Lanarkshire and is therefore rightly "A" listed. Its origins may be late 15th or early 16th century, being the fortalice (fortress) of the Barony of Braidwood. The structure is 25 feet square, built of 5 feet thick coarse rubble, and rises through 4 storeys to the parapet with an overlying garret chamber.

The Tower has belonged to the Lockharts of Lee since 1681. It was extensively renovated in 1861 by Sir Norman Macdonald-Lockhart.

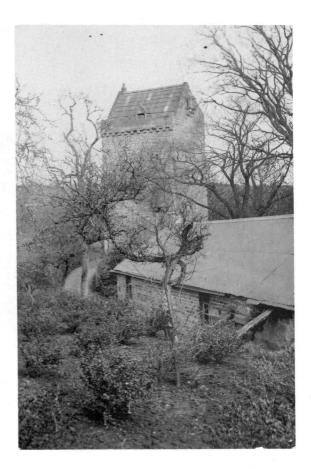

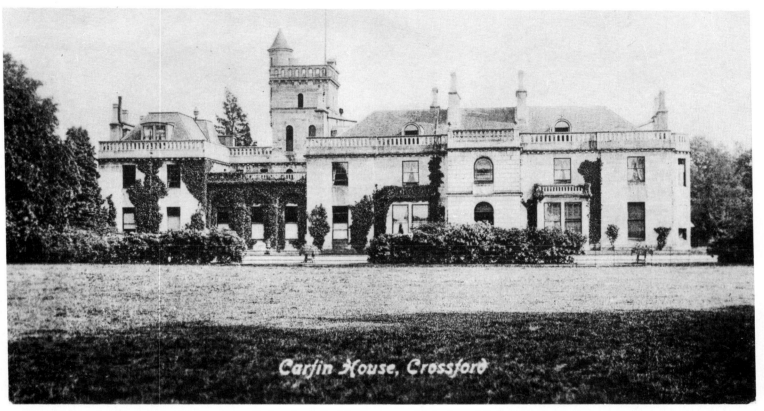

Carfin House, Crossford

Like Dalserf and Rosebank, Crossford also had its big house, which, in addition to the fruit and the pits, provided a welcome source of employment in the village. Carfin Estate occupied the north-east bank of the Clyde upstream from Crossford Bridge, but at one stage also extended across the river to Davingill. The house was probably built around the beginning of the 19th century and in 1824 the Nisbets were in occupancy. By the 1870s the estate was in the hands of the Steels and now called "Holmhead".

The "golden age" began with the estate's purchase by James Noble Graham in 1880 and his restoration of the name "Carfin". Graham was involved in the port wine trade and in the early years invested heavily in the running of his estate. Many of the villagers found work here and the village economy was in turn buoyed up as a result. Not surprisingly, the Graham family were popular and they in turn involved themselves in the community.

In the 1890s, Graham employed around six gardeners on Carfin Estate, who worked in the orchards, vegetable gardens, and woodland. They either lived in the village or in estate bothies.

By 1923, financial difficulties had emerged leading to Graham's bankruptcy. He continued to occupy the house, but died in Oporto in 1928.

From 1935, Youngs of Troon ran the estate as a poultry and fruit farming concern, establishing one of the largest tomato-growing businesses in the valley.

Carfin House, however, went the way of others in the area and was demolished in 1957.

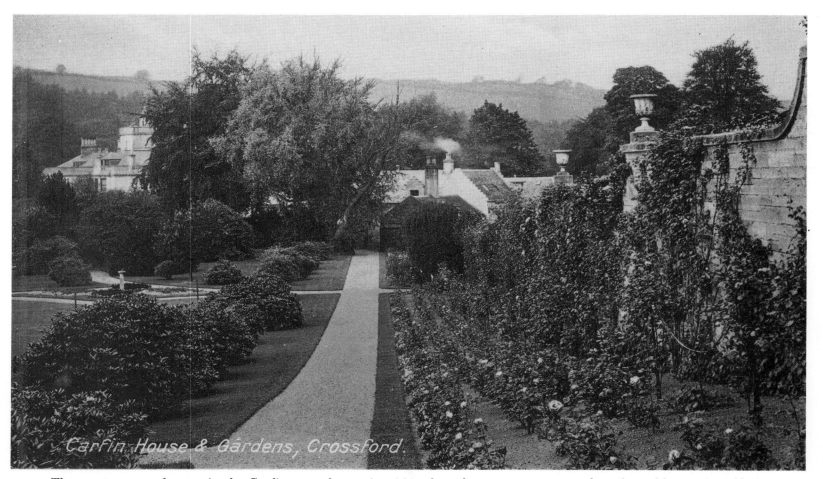

Carfin House & Gardens, Crossford.

The most recent chapter in the Carfin story began in 1989 when the estate was opened to the public as the "Clyde Valley Country Estate". A garden centre and coffee shop now occupy the walled garden area, while the restored coach house and stables house a range of shops and a restaurant.

At the time of writing, the splendid footbridge of 1887 has been fully restored to join the fine cast iron stork fountain as reminders of Carfin's vibrant past.

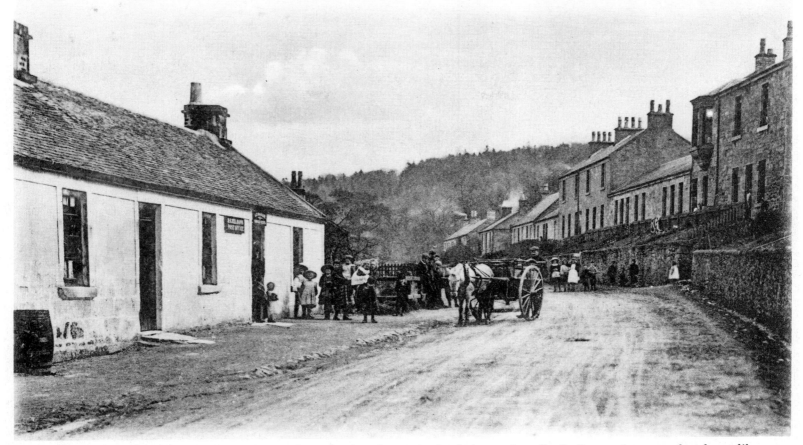

Hazelbank's charming name (see page 45) emphasises its central role in a primarily fruit growing area, but here, like Crossford, there was a division of labour between the orchard and the pit, village miners working up the "Braes" in the Auchenheath field or carrying on by rail to Coalburn.

Around the turn of the century the now shopless village supported several grocers, "sweetie" shops and even a pub. From the "sweetie" shop shown here (Jimmy Thomson's) the Post Office was also run, opening on the 9th February 1899.

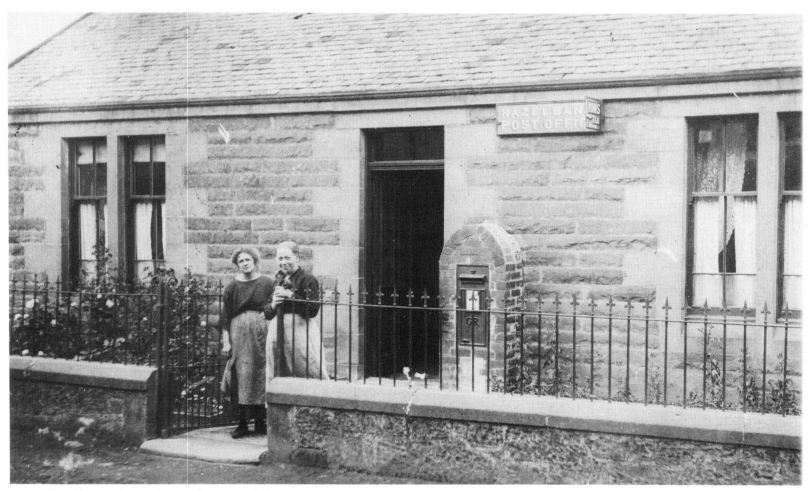

This later photo shows the Post Office having moved to the red sandstone cottage next door after a relatively short period in its original site. Mrs. Robertson ran the office here in the 1920s and 1930s. At least two later locations for the Post Office are known, both on the "Braes" side of the road. The postbox stands today outside where Hazelbank Post Office finally closed on the 29th November 1975.

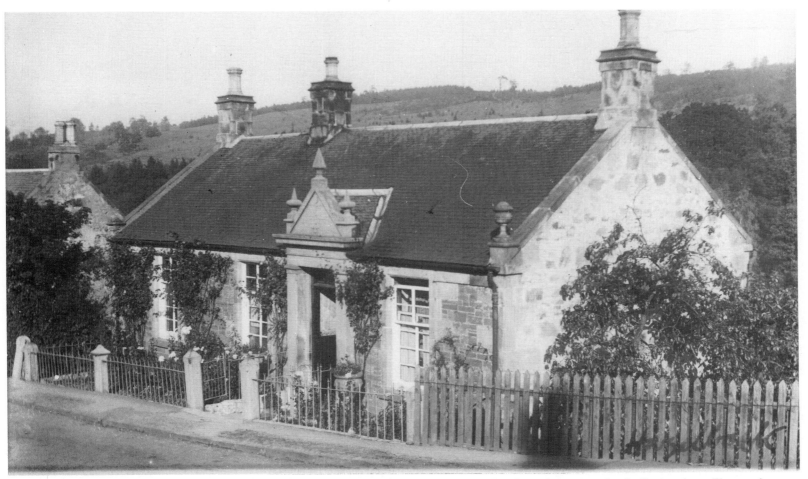

Although it is no longer known as such, this is Hazelbank Cottage, the first house to be built in the village of Hazelbank. It dates from 1803 and was built by an architect called Russell on ground obtained from Daniel Vere, the then owner of the Stonebyres Estate. The story goes that one day, as work continued on the house, Vere was passing by and in the course of the conversation the question of a suitable name for the house came up. The profusion of hazels on the bank to the river provided the solution.

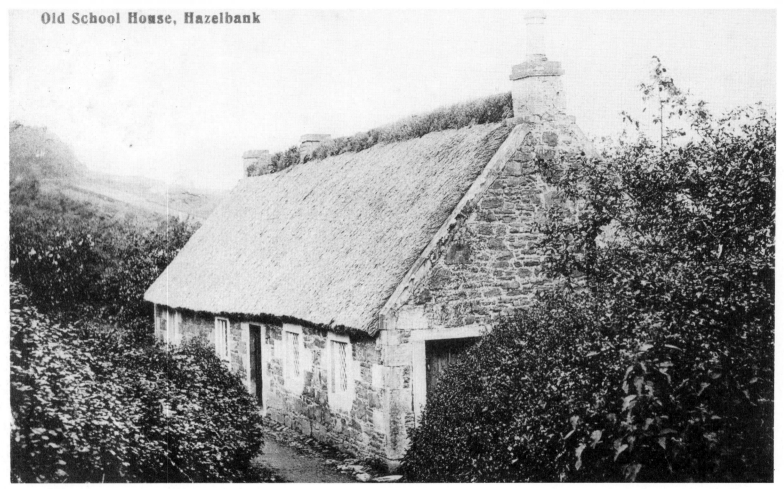

Old School House, Hazelbank

This little building was the school for Hazelbank from 1829 until about 1877. It was known as Stonebyres School. The site and at least some of the building costs were donated by Daniel Vere, owner of the Stonebyres Estate. The end in the foreground was the school, and the other half was accommodation for the schoolmaster. The school became redundant when the new school at Davingill opened. This photo dates from around 1904. By the 1940's, the thatched roof had been replaced by corrugated iron. The building is located on the "Braes" road to Auchenheath, and although modernised, retains much of its character.

46

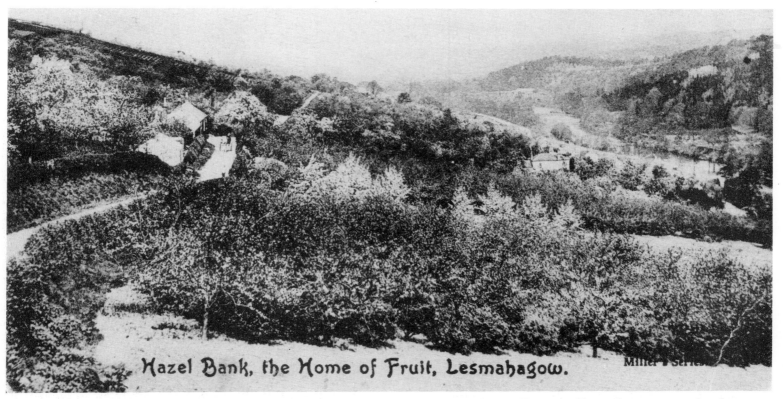

Hazel Bank, the Home of Fruit, Lesmahagow.

Miller's Series

This panoramic view downstream from the "Braes" reveals the Clyde Valley in all its fructuous splendour. Clydeside's flirtation with strawberries began in the 1870s, but by the 1920s serious problems (partly poor production techniques and partly disease) were affecting quality and yield. The acres of ground formerly under strawberries were returned to more conventional crops, but salvation was found for many in another fruit, the tomato.

Tomatoes had been introduced in the 1880s as a glasshouse crop. They reached the Valley (and possibly Scotland) first at Arthur's Crag, Hazelbank in 1882, and were soon established in the glasshouses springing up all over Clydeside prior to the emergence of the strawberry problem. It was therefore the obvious fruit for the strawberry growers to turn to.

Over the years since, tomato growers have also suffered difficulties, and somewhat ironically the concept of "pick your own" strawberries has in turn assisted in rescuing an ailing business.

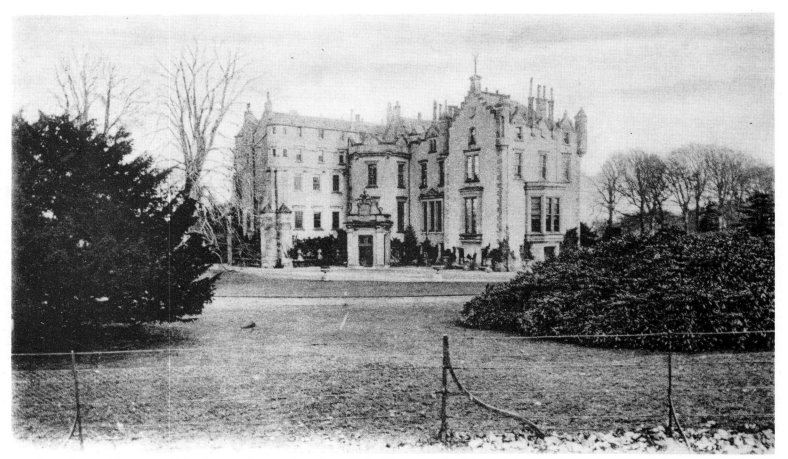

Stonebyres House, a 30 bedroomed mansion, demolished in 1934, had its origins in the 14th century, being an early seat of the Weir/Vere family of Blackwood. The house was considerably augmented over the centuries. James Noble Graham of Carfin purchased Stonebyres from Miss Monteath-Scott, and between 1906 and 1914 spent lavishly on the interior. From 1906, however, the house was occupied for only a few months, being resold to Miss Monteath-Scott in 1924, again remaining largely unoccupied until her death in 1933.

The estate was subsequently divided into small-holdings.

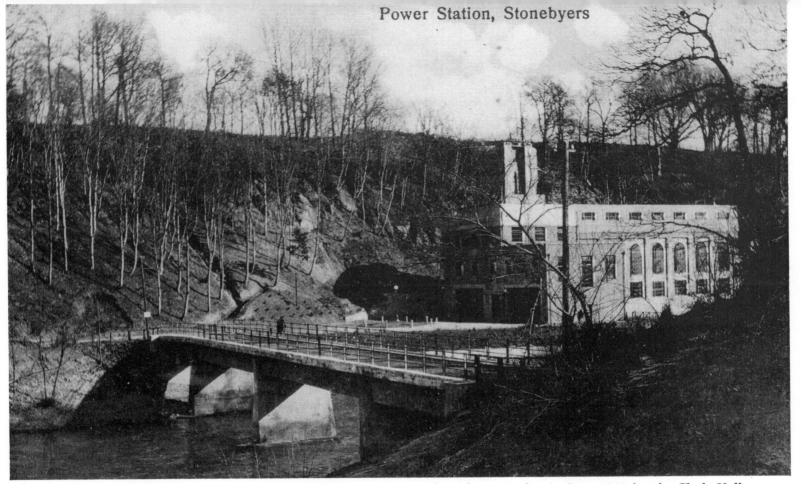

Stonebyres and Bonnington Hydro-Electric Works were opened on the same day in June 1927 by the Clyde Valley Electrical Power Company, Stonebyres harnessing 6,000 kw of power generated by the fall of 98 feet in the Clyde via a weir, tunnel and pipeline. The generators were replaced in 1970/71 by induction type machines under automatic and remote control.

Today Stonebyres contributes 5,000 kw to the National Grid, and, with Bonnington, is the oldest power station under the control of Scottish Power.

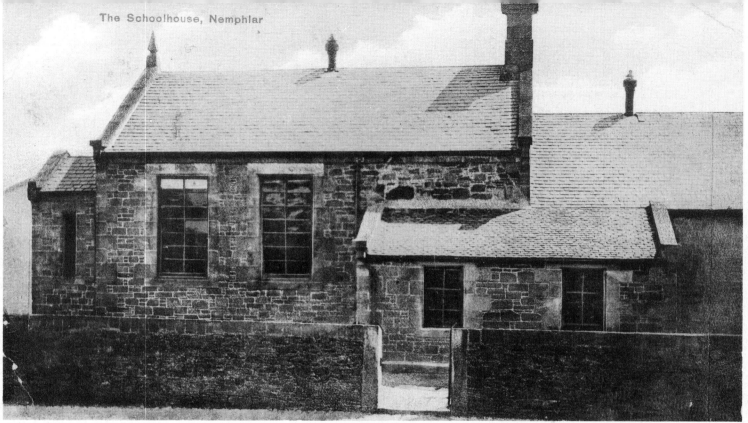

The Schoolhouse, Nemphlar

The village of Nemphlar occupies rising farmland overlooking Kirkfieldbank on the opposite bank of the Clyde. It is by-passed by major roads but in recent years has been developed for housebuilding.

Nemphlar is an ancient community with traditional associations with the Knights Templar. Employment in the 19th century was provided mainly by the adjacent Lee Estate but this was also a weaving community; in the 1850s there were more than 100 handloom weavers in Nemphlar, although by the following decade the industry was in decline.

For such a small community, Nemphlar was well provided for educationally. The School, in the care of Jessie Miller and her assistant, accommodated 49 pupils in 1906. There was even a library (with librarian) stocked with volumes gifted by Miss Macdonald-Lockhart of Lee. By 1951, however, only 14 pupils attended the school and the decline continued until its closure in 1966. It is the school, with schoolhouse, built in 1880, which despite the caption is shown here.

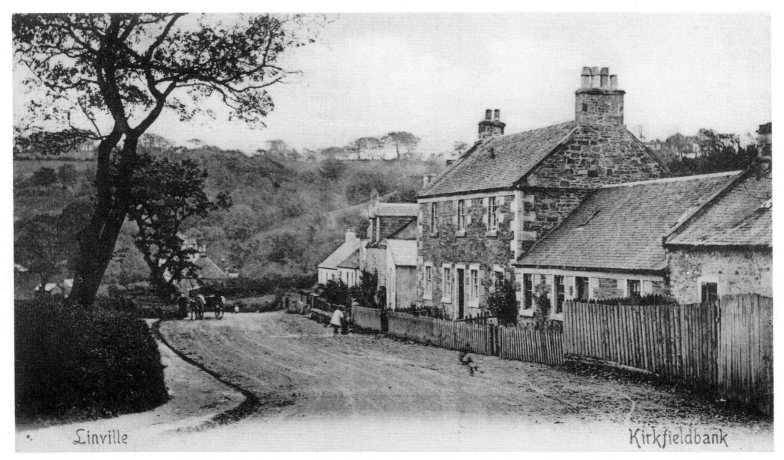

Kirkfieldbank appears in the midst of a series of contortions on the A72. The village consists of a trio of smaller former weaving hamlets, of which Linnville (Linville) is the first reached.

Andrew McDougall, originally a Glasgow joiner, rose through the ranks of J. Templeton & Co., carpet manufacturers, establishing on his own account a small 5 employee hosiery "factory" in Linnville in 1891. At the end of that year, McDougall leased space within the premises of J & R Meikle (see page 52). By 1900 business was booming and eight years later the expanding Linnville Hosiery Factory employing 180 workers moved to Delves Road in Lanark, becoming a major employer there.

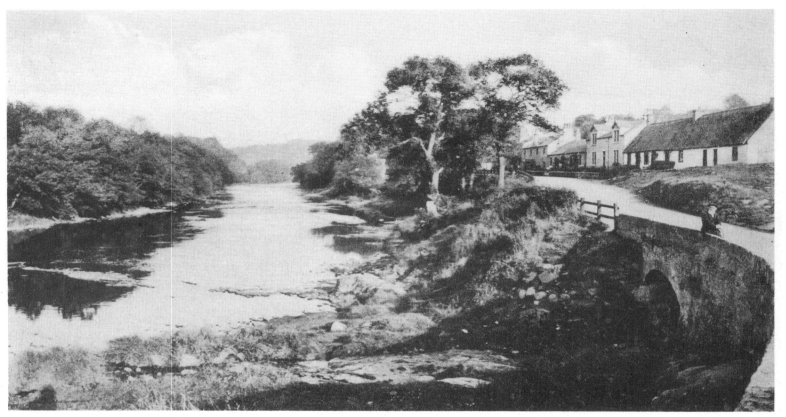

Dublin Bridge fords the Dublin Burn just before it enters the Clyde. On the right stand the old weavers' cottages of Dublin. The name may derive from a nucleus of Irish immigrants attracted to the area. An alternative local explanation stems from the existence of two cottage inns side by side adjacent to Meikle's factory (see below) and known as the "Double Inn".

Following the demise of hand loom weaving, work was available in power loom weaving factories. Just beyond Dublin, the factory of J & R Meikle employed 90 people, mainly female, in 1887. By 1896, electric light had been introduced and more than 100 looms and 130 employees were engaged. At that time, the weaving of skirtings was the main business, but well into the 20th century the factory (now Nicholson Plastics) was more renowned for its chenille curtains and covers.

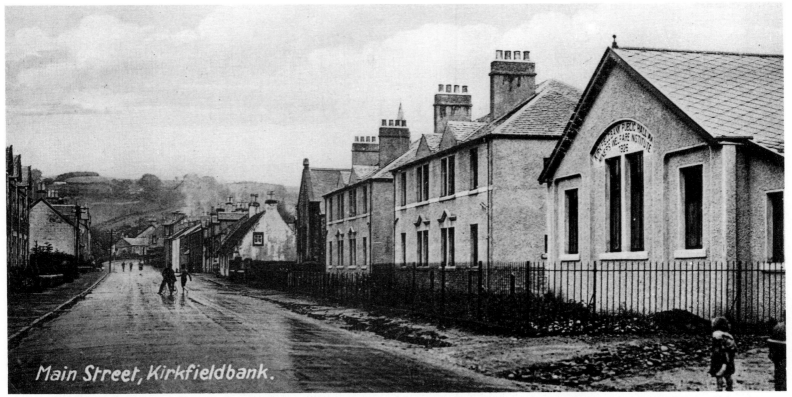

Main Street, Kirkfieldbank.

This view of the main part of Kirkfieldbank village dates from the late 1920s/early 1930s. The buildings discernible on the right hand side of Riverside Road remain largely unaltered today. The thatched cottage now has its roof concealed under metal. The adjacent red sandstone Baptist Church became the hall for Kirkfieldbank Church of Scotland prior to World War Two.

On the right of the two local authority housing blocks is Kirkfieldbank Hall, designed by Kerr and opened in 1906 by Mrs. Hyndman Stein of Kirkfield House. The hall was gifted by her husband in memory of their two sons, the original name being "Kirkfield Memorial Hall". The later inscription (visible above but now disappeared) reveals the unsuspected mining connections in this weaving and market gardening village. Kirkfieldbank miners faced a long journey to the pits of Auchenheath and Ponfeigh. On the right, just out of the photograph, stood a two-storey tenement block (Stein's Lawn — now gone), and beyond that the Public Park, opened in 1926 by Colonel Cranstoun of Corehouse on a site gifted by him to Lesmahagow Parish Council.

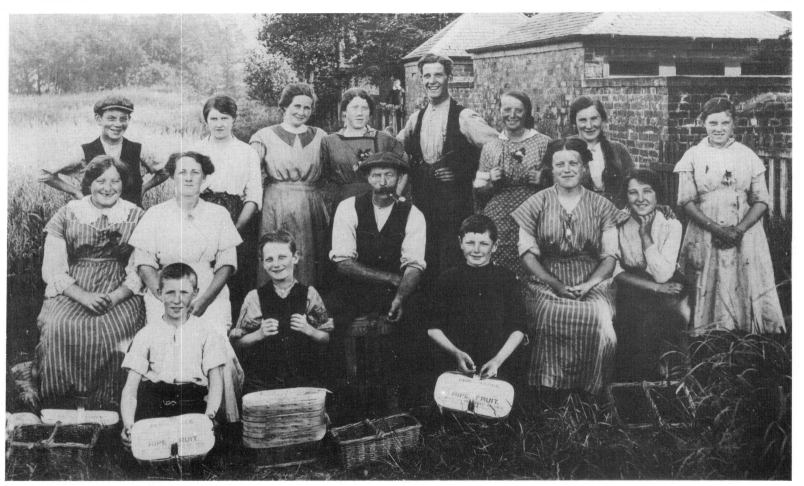

Robert McLellan, author and playwright, was born and spent much of his childhood at his grandparents' orchard farm of Linmill, including his reminiscences in a collection of short stories. He recalled the local berry pickers sleeping off their revelry in the barn bothy at Linmill. The "daft men" were posted in the strawberry fields to fend off the crows.

Many of the berry pickers (known locally as "Donegals") made annual trips from Ireland, moving on to the hay and potato fields later in the season. The wider availability of motor transport enabled local pickers (from Larkhall, for example), to be brought from the countryside and villages around on a daily basis.

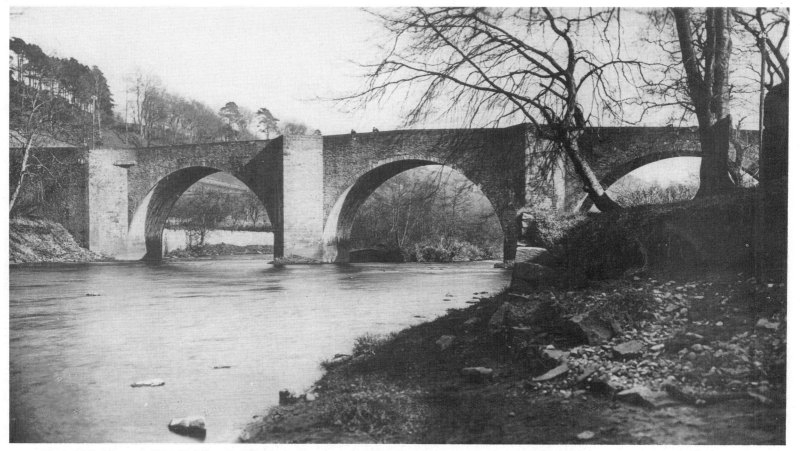

The old bridge at Kirkfieldbank (Clydesholm — "A" listed) was completed in 1699 and replaced a short-lived earlier bridge. Before this, it was necessary to ford the river above the island or to cross on horseback. In ancient times, a boat, "St. Catherine's Weal", plied here, so called because the revenue raised went to the upkeep of an altar in the Parish Church.

The advent of the bicycle and later the motor car was indirectly responsible for the replacement of the Old Bridge by a realignment of the road and construction of a new bridge (1959). The steep hill to Lanark combined a series of bends with a final severe hairpin bend at the bridge, leading to an increasing accident rate between 1900 and 1930 (when the idea of a new bridge was first explored). The Toll House, the site of many accidents, was removed in 1948.

SELECT BIBLIOGRAPHY

Beveridge, A.	Clydesdale. Descriptive, Historical and Romantic. A. Beveridge c.1883.
Clydesdale District Council	Historic Buildings of Clydesdale. Clydesdale District Council 1987.
Clydesdale District Council	Old Clydesdale in Photographs. Clydesdale District Council 1991.
Clyde Valley Tourist Board and Lanark and District Archaeological Society	Historical tours in the Clyde Valley. Scottish Tourist Board 1983
Hoy, C.F.	The Crossford-Hazelbank District. A survey of seventy years 1875 to 1945. David J. Clark Ltd. 1946.
McLellan, R.	Linmill — Short Stories in Scots. Akros Publications (Pentland Prose Series) 1977.

ACKNOWLEDGEMENTS

The illustrations on pages 9, 12, 15 and 20 are from Janet Murray's collection. Those on pages 24 and 37 are from post cards loaned by Bill Muir. All other illustrations are from the Richard Stenlake collection.

John Hunter kindly assisted with photographic work.

Old Town, Kirkfieldbank